COPYRIGHT © 2018

ALL RIGHTS RESERVED. NO PART OF THIS PUBLICATION MAY BE REPRODUCED. DISTRIBUTED, OR TRANSMITTED IN ANY FORM OR BY ANY MEANS, INCLUDING PHOTOCOPYING. RECORDING, OR OTHER **ELECTRONIC OR MECHANICAL** METHODS, WITHOUT THE PRIOR WRITTEN PERMISSION OF THE PUBLISHER EXCEPT IN THE CASE OF BRIEF **QUOTATIONS EMBODIED** IN CRITICAL REVIEWS AND CERTAIN OTHER NONCOMMERCIAL USES PERMITTED BY COPYRIGHT LAW

DOG BUTTS

COLORING BOOK

THIS BOOK BELONGS TO

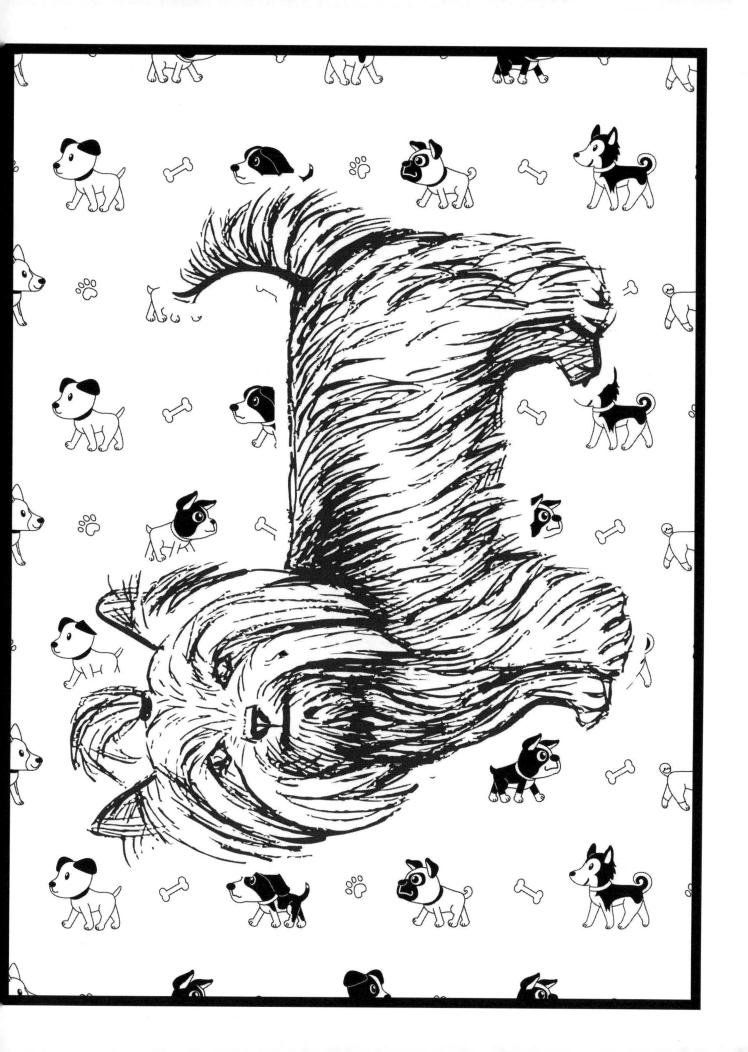

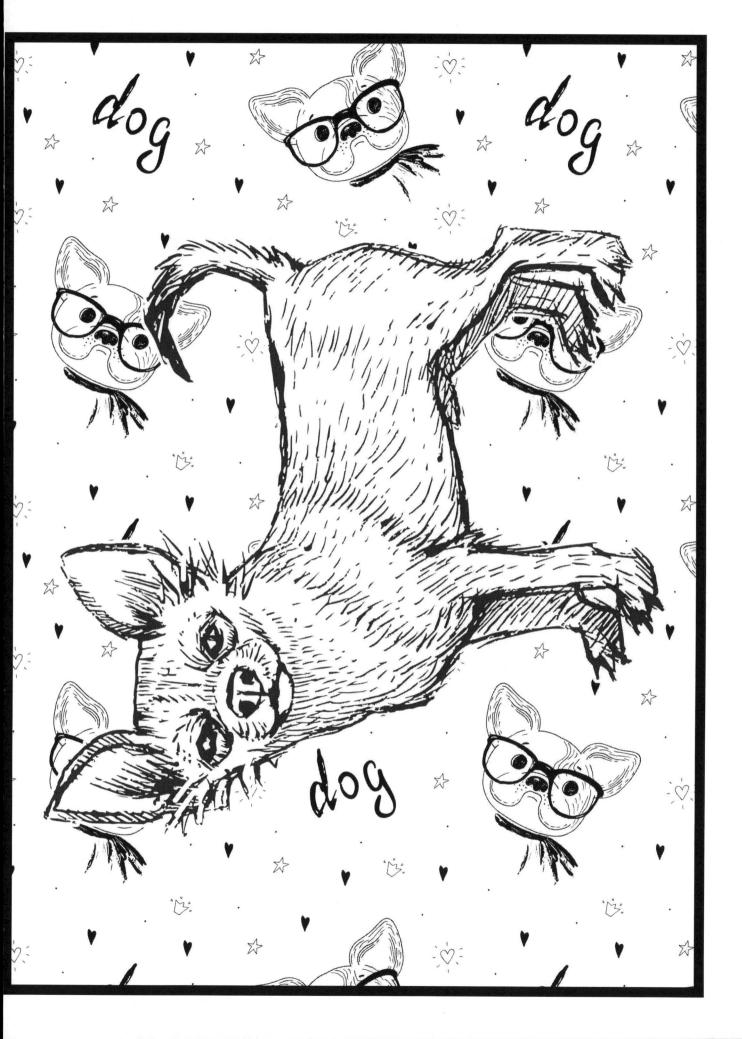

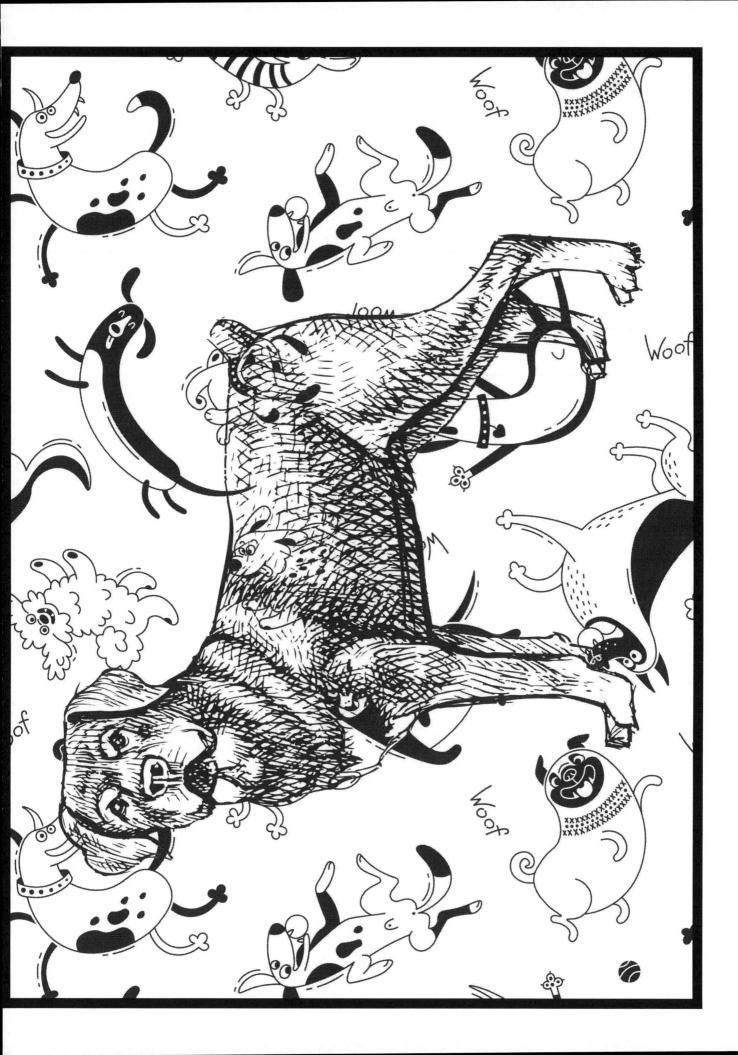

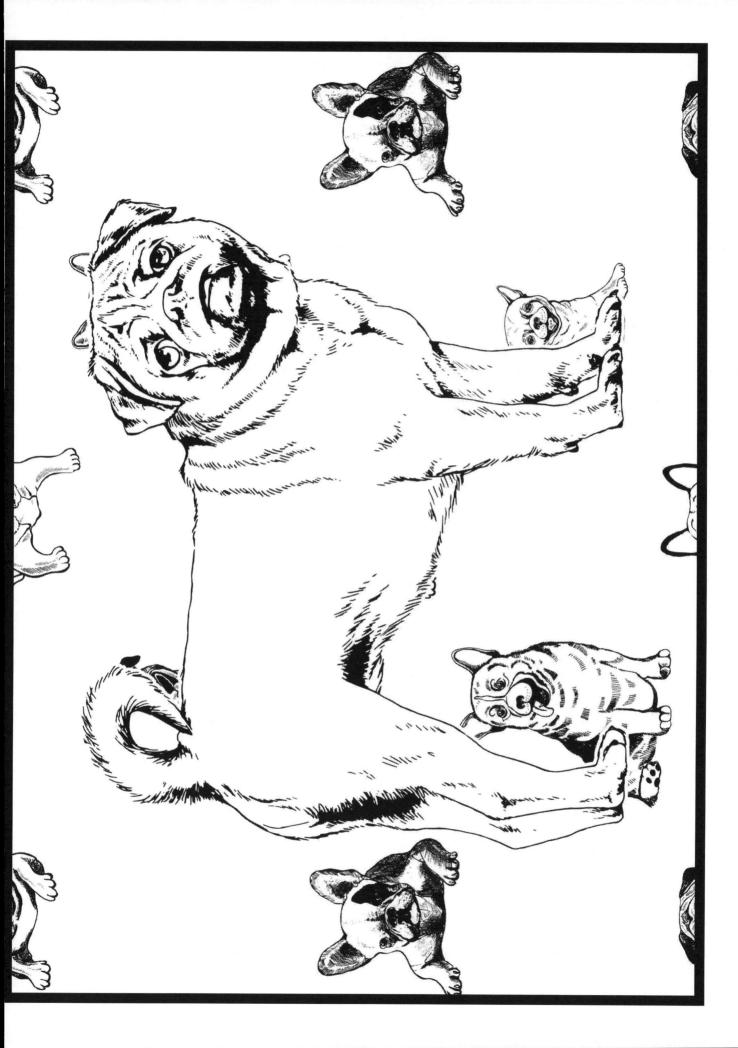

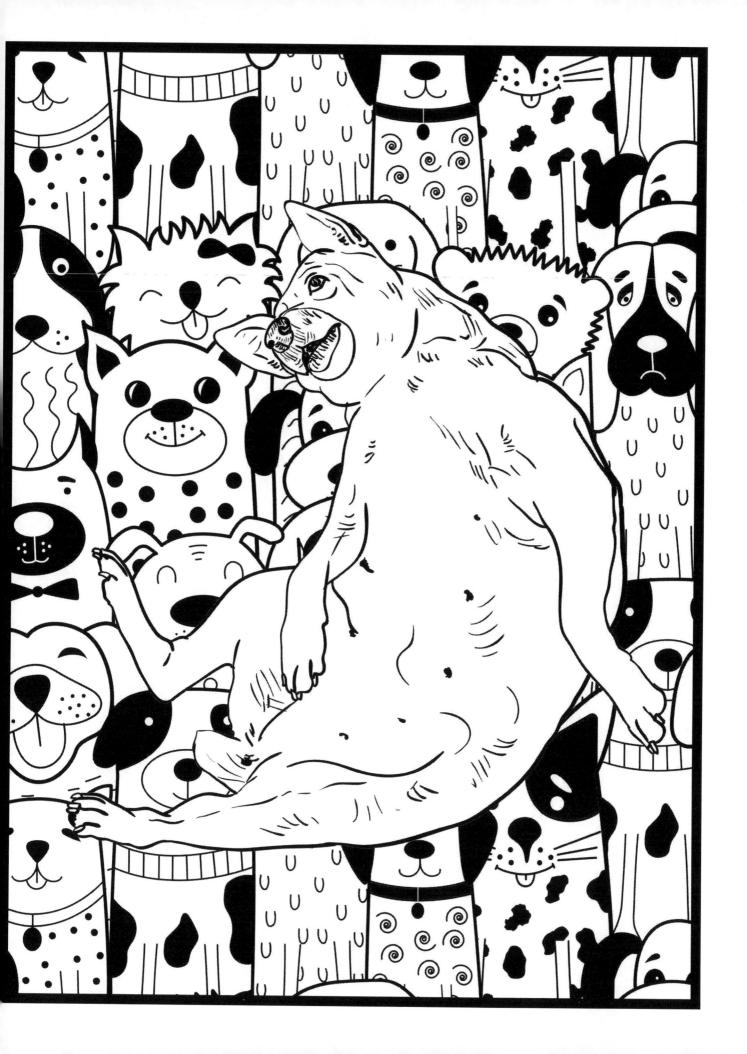

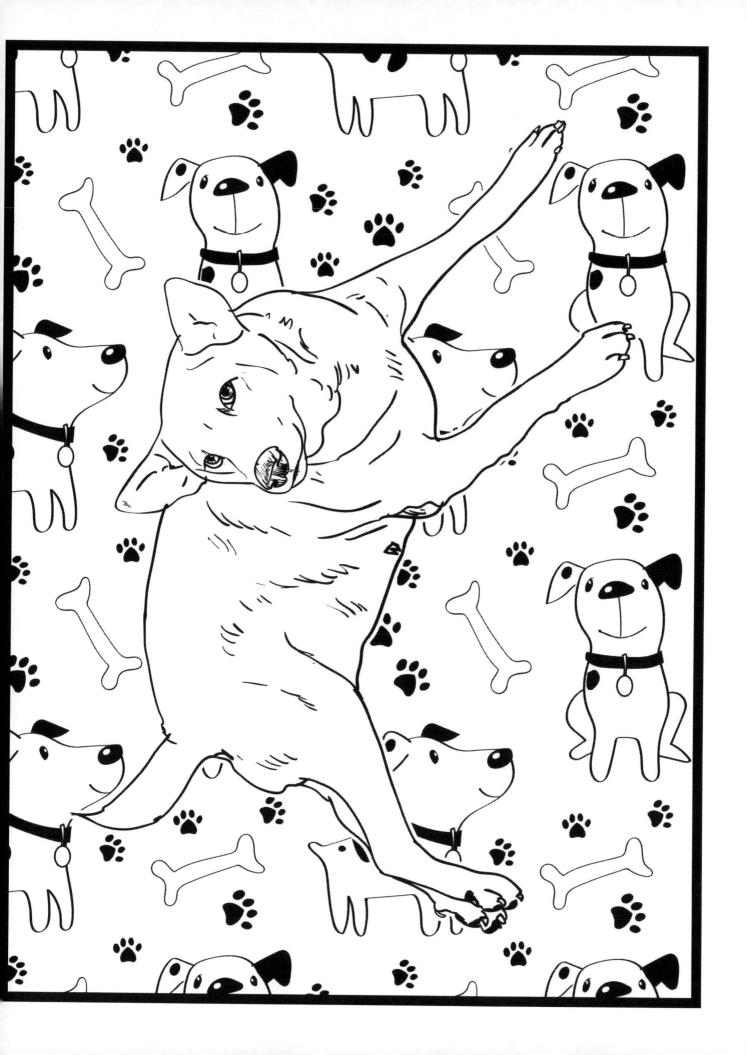

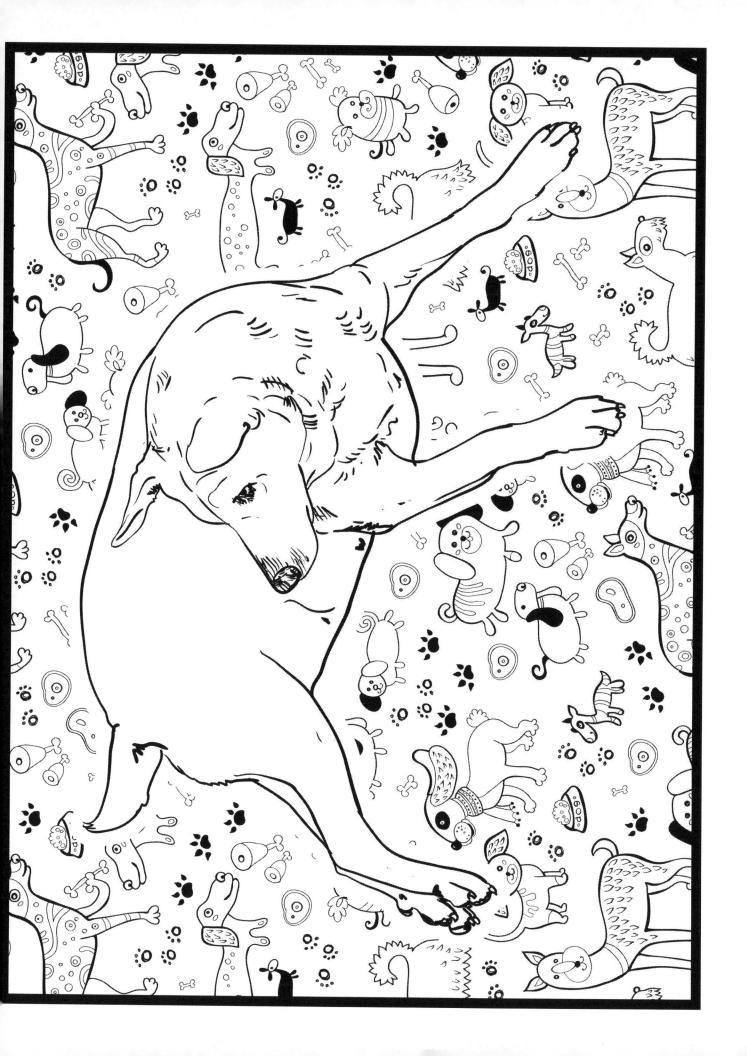

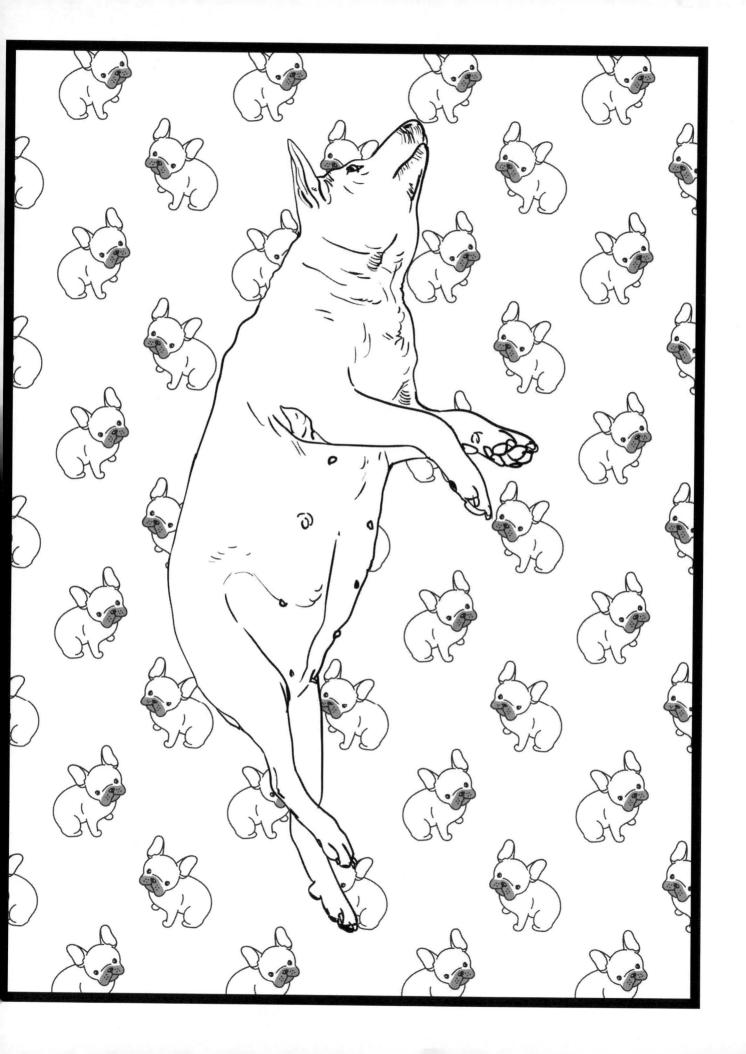

Made in the USA Middletown, DE 09 November 2018